CLAY

Jeannie Hull

Consultant: Henry Pluckrose

Photography: Chris Fairclough

FRANKLIN WATTS
London/New York/Sydney/Toronto

First published in the United States in 1989 by
Franklin Watts Inc.
387 Park Avenue South
New York
NY 10016

Library of Congress Cataloging-in-Publication Data

Hull, Jean,
 Clay / by Jean Hull.
 p. cm. – – (Fresh start)
 Includes index.
 Summary: Gives instructions, in step-by-step photographs, for
preparing clay and making thumb and coil pots and decorated tiles
and how to use glaze.
 ISBN 0-531-10757-4
 1. Modeling – – Juvenile literature. 2. Clay – – Juvenile literature.
[1. Modeling. 2. Clay.] I. Title.
TT916.HB5 1989
731.4'2 – – dc20
 89–9959
 CIP
 AC

Design: K & Co
Editor: Jenny Wood
Printed in Belgium

The author wishes to
thank Henry Pluckrose
for his encouragement
and patience during the
preparation of this book.

DEDICATION
To all the children who
have potted with me.
Jeannie Hull

Contents

Equipment and materials 4
Getting ready 5
Pinch pots 6
Joined pinch pots 12
Wedging – preparing your clay 18
Coil pots 20
Tiles – impressed decoration 28
Tiles – applied decoration 34
Slab pots – making a box 37
Firing and glazing 41
On your own 44
Further information 45
A brief history of pottery 45
Index 48

This book describes activities which use the following:

Apron (or old shirt)

Boards (for working on, and for leaving finished work on, to dry)

Box (for your personal tools – an old shoe box would do)

Card (thin)

Clay (red and white earthenware)

Dish towel (old, or old piece of sheeting without holes)

Glazes (in containers)

Junk materials (e.g., clothespin, ballpoint pen, screw, old fork)

Kiln (use only when you have the help of an adult who knows how to fire clay)

Kitchen knife (old)

Materials from nature (e.g., leaves, shells, twigs, pieces of bark, nuts, pine cones)

Needle (keep it in a cork)

Newspaper

Paintbrushes

Paper (for drawing on)

Pencil

Plastic bucket

Plastic carrier bags (or plastic from dry cleaning)

Rolling guides (two strips of wood, each about ½ inch x 12 inches, or ¾cm x 30cm)

Rolling pin (wooden)

Ruler

Scissors

Scourer (nylon)

Sponge

Sticks (for stirring glazes)

Table (with a wooden surface, for working on)

Water

Wire (for cutting – fishing line will do)

Wooden tools

Yogurt containers (or old jam jars)

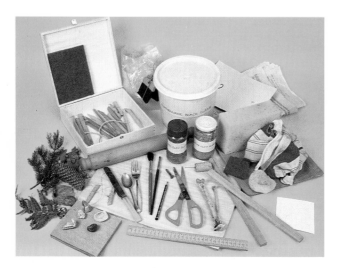

Clay

Clay is a stiff, sticky kind of earth. It is one of the most common materials on the surface of our planet and can be found on plains, in river valleys and in garden soil. Clay is produced by the gradual weathering of rocks, over millions of years.

The projects in this book use red clay or white clay. These are both secondary clays. "Secondary" is the name given to clay that has been carried from its original site by the action of glaciers and rivers. While on the move, the clay gathers impurities and minerals such as iron. Iron gives red clay its color.

Firing

To make clay into a permanent substance, it has to be baked at a very high temperature. This is called "firing" and is done in a kiln. A kiln is a special type of oven used by potters (people who make pots and other objects from clay). Some kilns are gas-fired, others use electricity or burn wood. All give different results. The one thing all kilns have in common is that you are never quite sure how your pots are going to look after the final firing. It is always very exciting waiting for your finished work to appear.

Glaze

Glaze is the coating applied to a clay pot to make it waterproof. Glaze comes in many different colors. But beware – the color of the liquid glaze is never the same as the final result. Always read the labels on the glazes, to make sure you know what you are getting.

Suppliers of clay, glazes and kilns are listed on page 44.

Preparation

Before starting work on any of the projects in this book, you should put on an apron or an old shirt. You should also have clean hands and a clean table to work on (spread newspaper on the table if you like). Making clay pots should be a clean, tidy occupation. Messy workers make messy pots!

Pinch pots were almost certainly the first pots ever made. They were used for religious celebrations, and to store food.

Start with simple, compact shapes. After a few attempts you will begin to get the feel of the clay and find out what it will or will not do.

You will need a board for working on, a board for finished work, red clay, a damp sponge, a piece of wire, wooden tools, a knife and a nylon scourer.

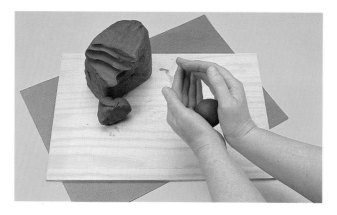

1 Take a piece of soft (but not sticky) red clay about the size of a golf ball. Cup your hands and gently pat the clay into a smooth, round ball – rather like making a snowball.

2 Hold the ball in one hand, keeping that hand cupped. Push the thumb of the other hand into the middle of the clay to make a hole (keep the thumb straight). Leave about ⅜ inch (1cm) thickness of clay between the tip of the thumb and your cupped hand.

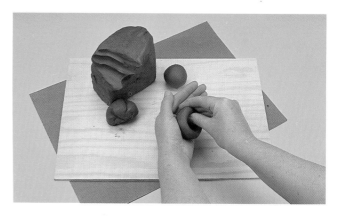

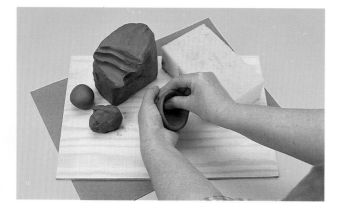

3 To turn your ball of clay into a pot, you must "pinch and turn" until the walls of the pot are of an even thickness. First, gently pinch the clay between the thumb and fingers of one hand. Turn the clay around a little in the cupped hand, and repeat the gentle pinching. Get into a rhythm of pinching and turning, always keeping the thumb inside and straight.

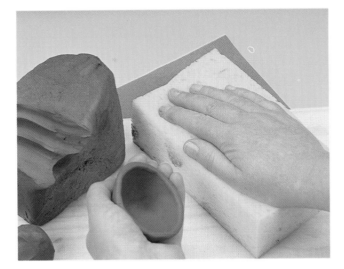

4 & 5 You may find the rim of the pot is cracking and splitting. If so, dampen your hands on the sponge and smooth over.

5

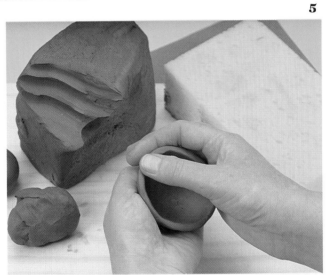

6 Cut through the pot with the piece of wire to check that the walls are of an even thickness. It is easy to spot mistakes!

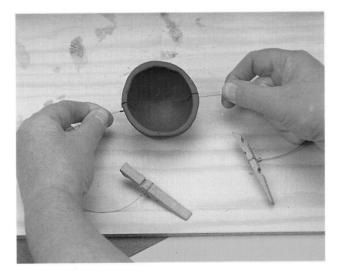

It is often a good idea to work with a friend. Ask them to feel your pot and test the evenness of its walls.

Faults such as a lump on one side or too much clay on the base can be corrected easily. If you have pinched too hard and have a thin wall, try squeezing or pushing the clay together. If that doesn't work, abandon that piece of clay and start again.

Roll any piece of clay you are abandoning into a ball and set aside. Any little bits left on your fresh, soft clay will stick when dry and spoil your work.

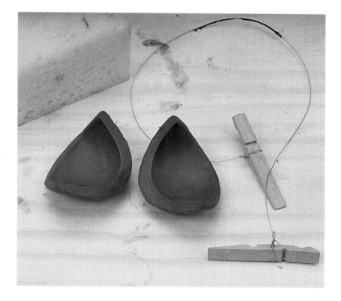

7 The two halves of your pot should look like these. Flatten them by gently pushing them down on the table. Set aside.

8 Take a fresh ball of clay and make a new pot. Remember any previous mistakes and try to correct them. Tap your new pot on the table. The flat area this makes on the pot's base will stop it rocking about. Try stretching it into different shapes. See how far you can stretch the shapes without splitting the clay. Set aside.

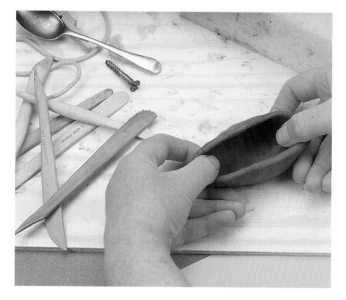

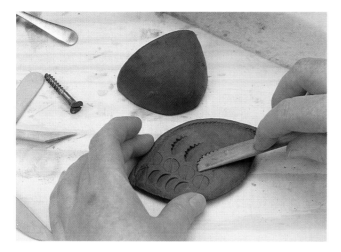

9 Return to the two flattened halves. Take any of the wooden tools and press them into the clay to make patterns on the pot's surface. (You can also make patterns with a clothespin, a piece of string, a screw, a pebble or even your finger.)

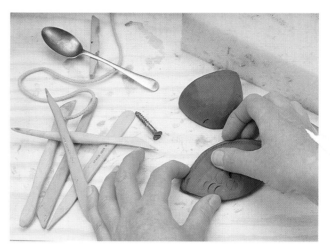

10 If you do not like any of the patterns you have made, smooth the clay with your finger and thumb and start again.

11 Decorate your new pot with your favorite pattern. Put your fingers inside the pot, as a support.

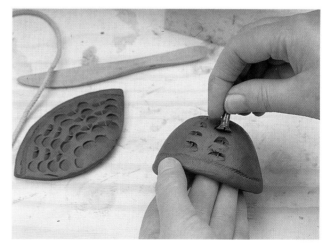

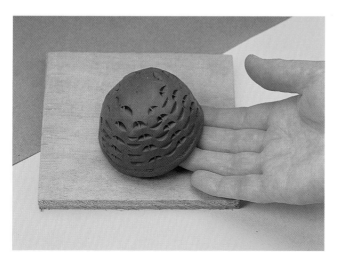

12 Put the finished pot on to a board and leave to dry.

13 When the pot is almost dry, take a knife and gently scrape off any sharp edges made by the decoration.

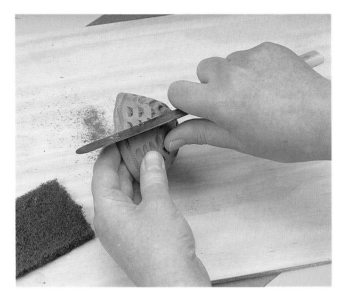

14 Smooth the bottom of the pot with the nylon scourer, if necessary. Don't rub out the pattern! Your work is now very brittle and can break easily, so take great care. Set aside to dry off completely. In a dry atmosphere, this may take about one week. If the atmosphere is damp, drying may take as long as two weeks.

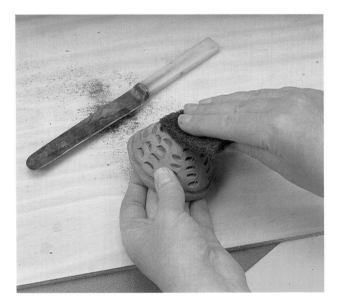

Before starting a new session of potmaking, look at the pot you made last time. You will notice that it has shrunk a little. This is due to the water in the clay evaporating as the pot dries out.

15 This type of decoration is called impressed decoration.

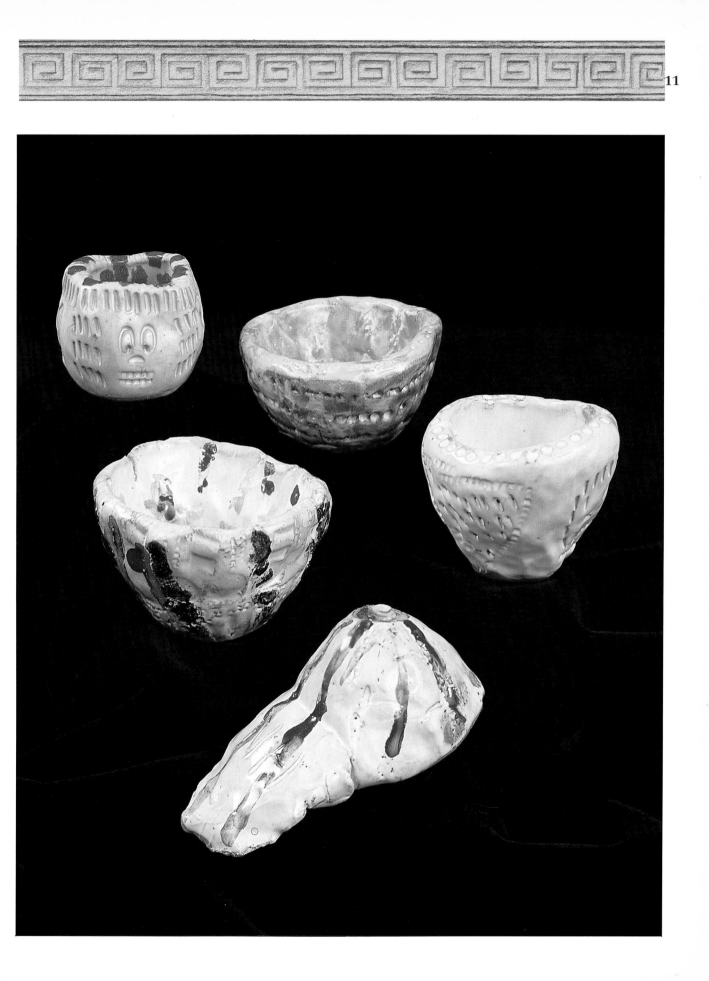

You will need a board for working on, a board for finished work, red clay, a needle, an old yogurt container (or jam jar), water, a sponge, a paintbrush, wooden tools, plastic and slurry.

Slurry is clay's glue. Break off some small pieces of red clay and put them into the yogurt container or jam jar. Now add some water and stir until you have a mixture the consistency of thick cream. (Any unused slurry will keep till next time, if you cover it with a lid. If it does dry out, just add a little water and stir.)

1 Take two pieces of clay as near the same size and weight as possible.

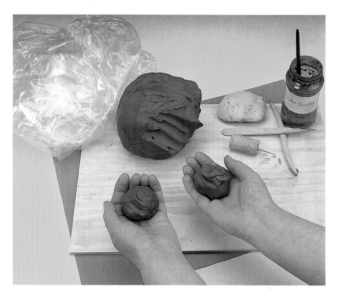

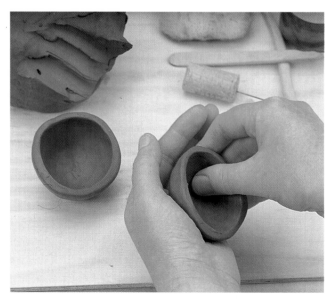

2 From these two pieces of clay, make two pinch pots the same shape and thickness.

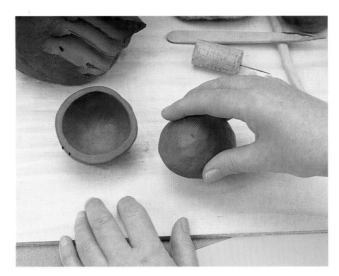

3 Gently tap the tops of the pots on the table to make them level.

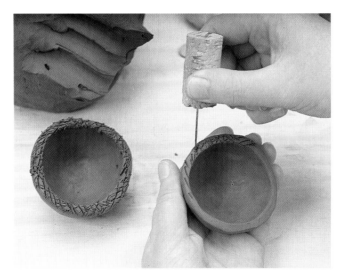

4 Score the tops of the pots with the needle tip. Make as many scratches as possible.

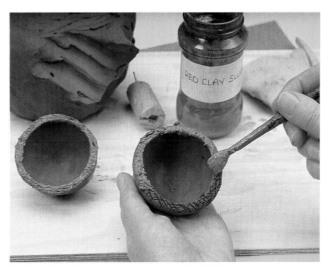

5 Using the paintbrush, blob plenty of slurry on to the scratched surfaces.

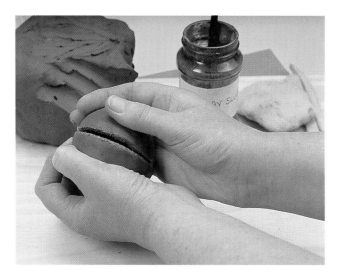

6 Push the two pots together. It is quite difficult for a beginner to make two identical pots, so a little coaxing may be necessary.

7 You now have a hollow egg shape. To get rid of the join line, hold the egg in one hand, wipe off any surplus slurry and with the thumb or finger of the other hand, smooth across the line (*across* the line, not *along* it – you will get a stronger join this way).

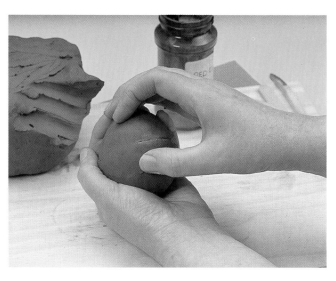

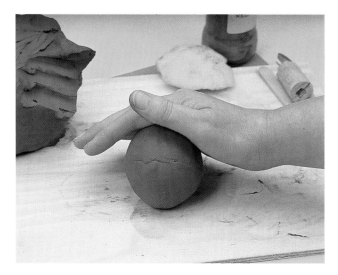

8 Roll the shape on the table to make it smooth. Repeat these two stages (see photos 7 and 8) until no join line can be seen.

9 This hollow egg shape can now become the body of a piggy bank, frog, space rocket, monster, turtle or anything else you can think of. If your chosen object needs legs and/or arms, model pieces of clay to suit.

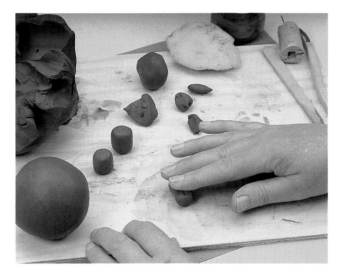

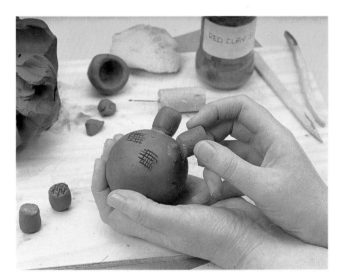

10 Place legs and/or arms in position, and fix by scratching and blobbing (see photos 4 and 5).

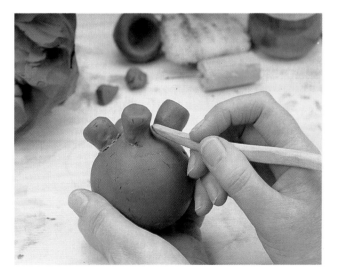

11 A wooden tool may be useful to help attach legs and/or arms.

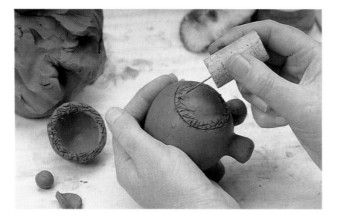

12 Make a small pinch pot for the head. Join it to the body by scratching and blobbing. (If you do not join by scratching and blobbing, any pieces you add will fall off when the clay dries.)

13 Finally, make a hole in the bottom of your object with the needle to let out the air. (Clay shrinks when it dries; air does not, so your object may split if you do not put a hole in the bottom.)

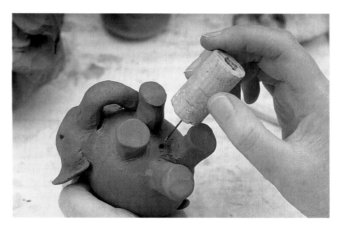

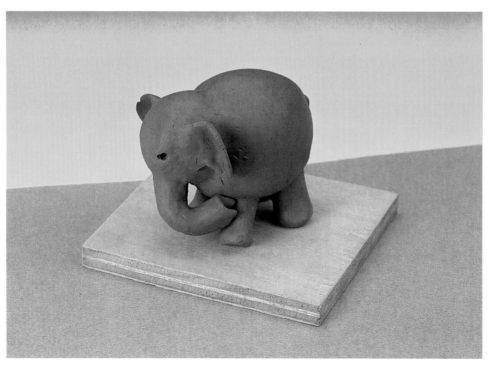

14 Leave your object on a board to dry. If you do not finish it that day, cover it with plastic. Covered properly, it will keep moist for a long time.

15 All these objects (right) were made using joined pinch pots. (If you want to make a piggy bank, you will need to cut a slit for the money with a needle.)

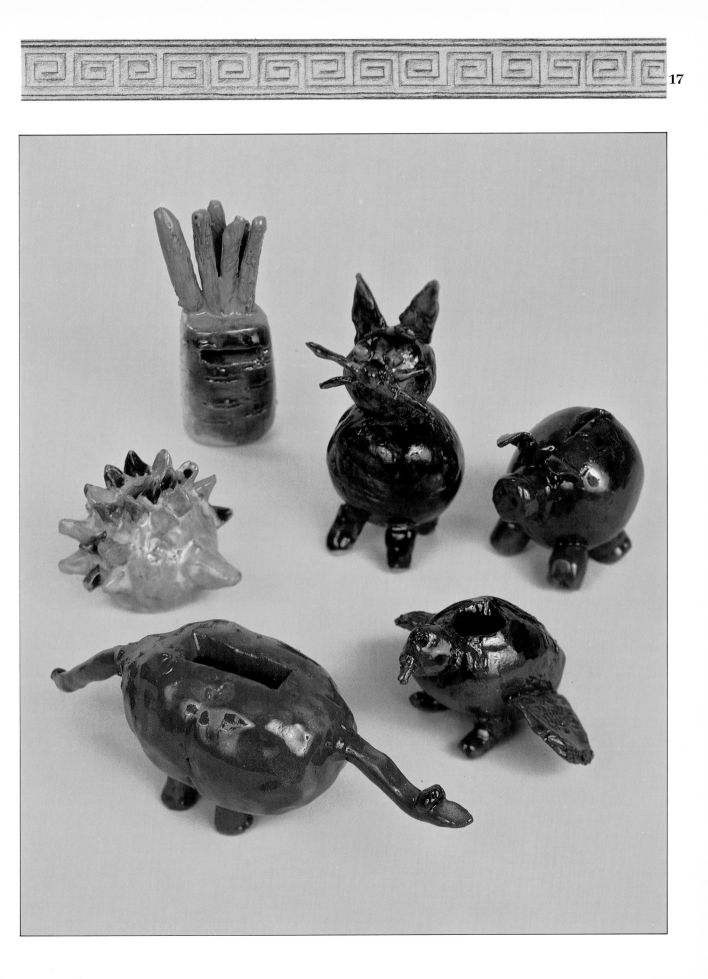

Wedging means blending clay together to make it an even consistency. It is very similar to kneading dough for bread, but for opposite reasons. In pottery, you are trying to get rid of the air bubbles; in bread-making you are adding them in.

There are various ways of wedging clay. The one described here is called the "Bull's Head Method."

You will need a wooden table (clay sticks to formica), white clay, wire, and a plastic bag.

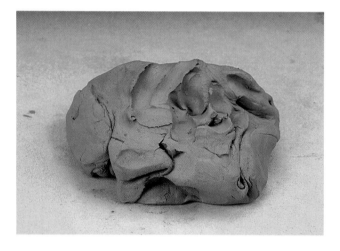

1 Take a ball of clay the size of two or three tennis balls.

2 Stand at the table. Cup your hands around the clay. Using your palms, push the clay downward and forward on the table, keeping your fingers around the clay to stop it squeezing out sideways. Let the weight of your body help you.

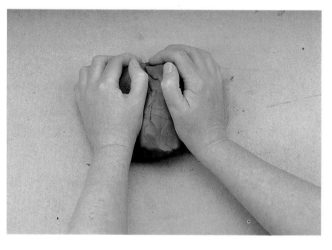

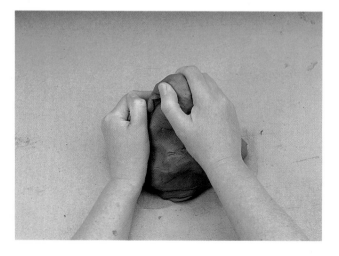

3 Roll the clay toward you, rotating it a little at the same time. Repeat these two stages (see photos 2 and 3) several times.

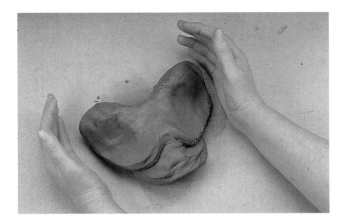

4 Soon a bull's head shape should emerge. Repeat the stages shown in photos 2 and 3 several times more.

5 Using the wire, cut the "head" in half through the nose. The cut sections should be perfectly smooth. (Any cracks mean that there are still air bubbles in the clay. If your clay is not properly prepared, your pot may break in the firing, so put the two halves together and continue wedging for a little longer.)

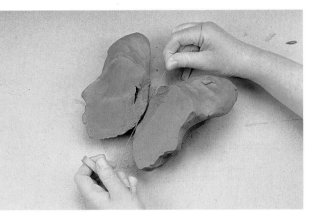

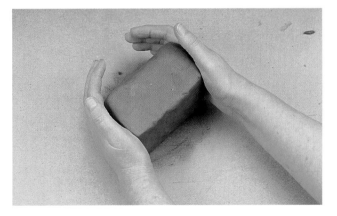

6 The clay is now ready to use. Bang it into a brick shape.

You can always wedge up more clay than you need to use that day. Put what is left into a plastic bag. As long as it is wrapped up properly no air can get in, and it will keep indefinitely.

If you have a clean plastic bin with a lid, store the plastic bag in that.

You should use wedged clay for all the other projects in this book.

Making coils

Coiling is a method of making a pot by laying one coil of clay on top of another, joining them and so building up a shape. Coil pots can be extremely large and more or less any shape you choose. Be warned, though – rolling good clay coils takes a little practice.

You will need a board for working on, a board for finished work, wedged white clay and a damp sponge.

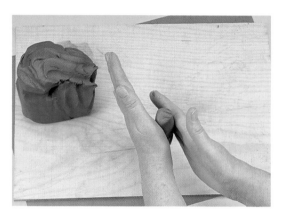

1 Pinch off a piece of clay about the size of a tabletennis ball. Make a sausage in the air.

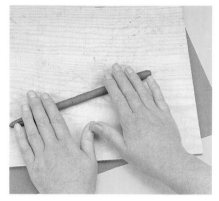

2 Using the whole length of your hand, from fingertips to wrists, roll the clay sausage on the table forward and backward with even pressure.

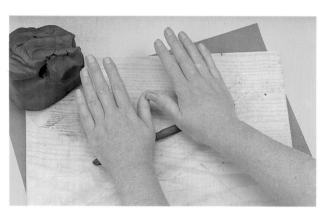

3 Stop when the sausage is about the thickness of your little finger. (As with pinch pots, coils should be of even thickness.) Repeat until you have made six or seven coils.

4 Things can go wrong! The top coil in this photo has become flat, like a plank. The middle coil has become twisted, like a corkscrew. The bottom coil has become dry and broken.

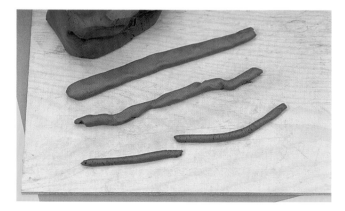

If your coil becomes like a plank, it means that you are pushing the coil away from you harder than you are pulling it towards you. Try putting the plank on its side then gently push down and continue rolling. Be conscious of using even pressure and a light touch.

A "corkscrew" coil usually means that you are not keeping your fingers together and that your hands are rolling independently. Let your thumbs touch and keep fingers together, as shown in photos 2 and 3.

If your clay begins to dry up, you can try dampening your hands on the sponge, but it may be best to start again with a fresh lump. Put any dry bits aside – you don't want crumbs attaching themselves to the fresh clay.

5 To start the base of your coil pot, roll one coil around and around tightly, like a curled-up snake.

6 One coil is not usually long enough to make the base. Pinch the end of another coil.

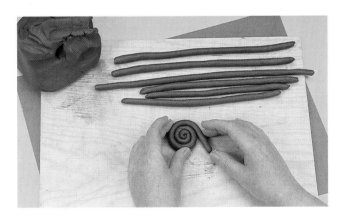

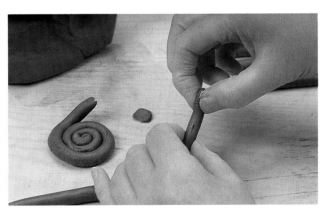

7 Join the two coils by tucking the ends into each other. When the base is large enough, push the end in and place the base on the board.

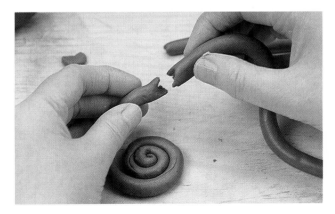

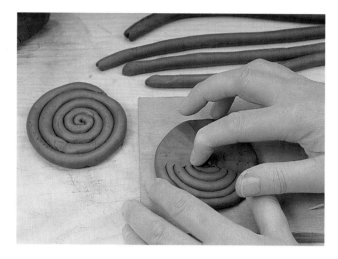

8 Smooth *across* the coils with your finger, moving from outside to middle. (If you smooth middle to outside, you open up the coils.) Turn the base as you go.

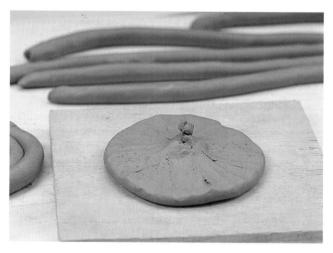

9 A pimple will develop in the middle of the base – push it down. Turn the base over and do the same on the other side. The base has to be really strong and watertight.

10 To make straight sides for your pot, start by laying a coil on top of the base.

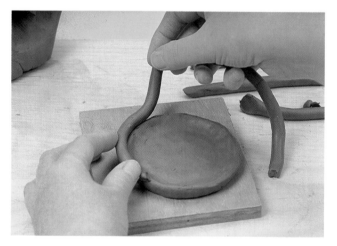

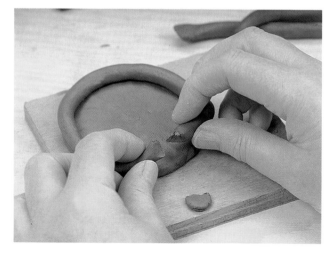

11 When you have a ring, pinch the ends and join.

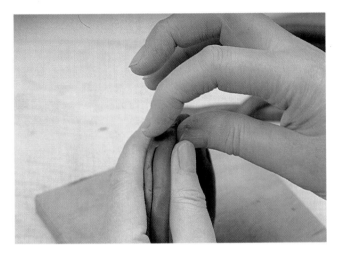

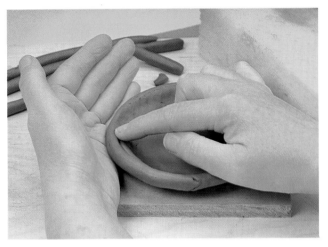

12 Joining the first few coils to the base is always tricky. A good way is to lift one side of the base in one hand and smooth upwards *across* the coil with the other hand.

13 To make the sides of your pot curve outwards, place the next coil on the *outside* of the coil underneath. Join using thumb or finger. To make the sides curve inwards, place the next coil on the *inside* of the previous one.

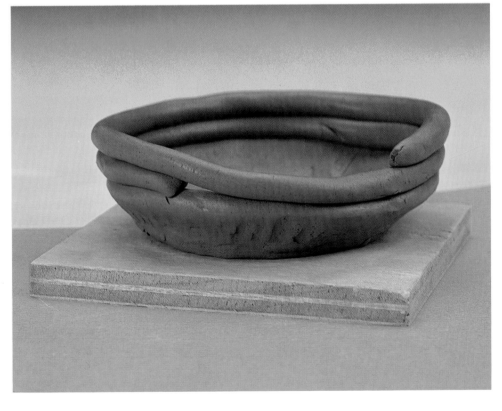

14 If you carry on spiraling the clay instead of joining the ends of each ring, a hole can develop which, although filled in, can become a weak spot. If you want your pot to have an uneven top, simply cut the end when you have finished.

Your first piece

You will need a board for working on, a board for finished work, drawing paper and pencil, wedged white clay and a damp sponge.

Let's make a vase. First think about the design. The top of a vase needs to have quite a narrow neck. If it is too wide, the flowers will fall all over the place. The base, on the other hand, must be wide enough to stop the vase toppling over.

15 Bearing these points in mind, draw lots of vase shapes on a piece of paper. Have a look at your designs.

16 Choose the best design and draw it again on a clean piece of paper. Use this as your working drawing. Roll several coils. Make the base about 3 to 4 inches (8-10cm) in diameter. Work out the height, then build up your shape, following your drawing as far as possible. (When you near the top and the shape becomes narrow, you may find you cannot get your hand inside to join the coils. Don't worry, as long as the coils are joined on the outside.)

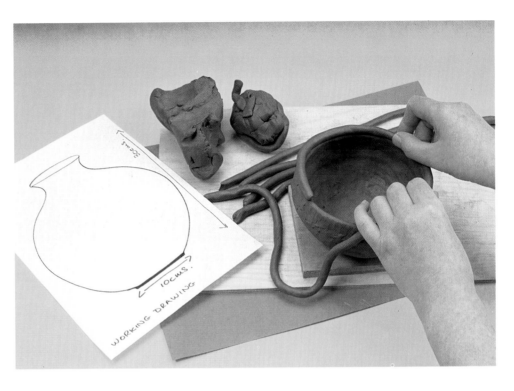

The exciting thing about coil pots is that they don't have to be round – you can start with an oval or squarish base and alter the shape as the pot grows. Remember, though, to keep your coils of even thickness (keep a sample coil for reference). Thin areas are weak and can cause a pot to sag and lose its shape. Thick areas tend to crack when they dry and also make the end result very heavy.

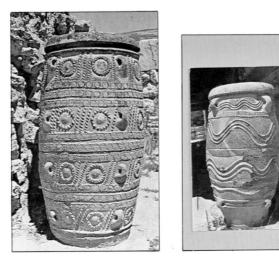

17 Coil pots can be as large as your kiln will allow.

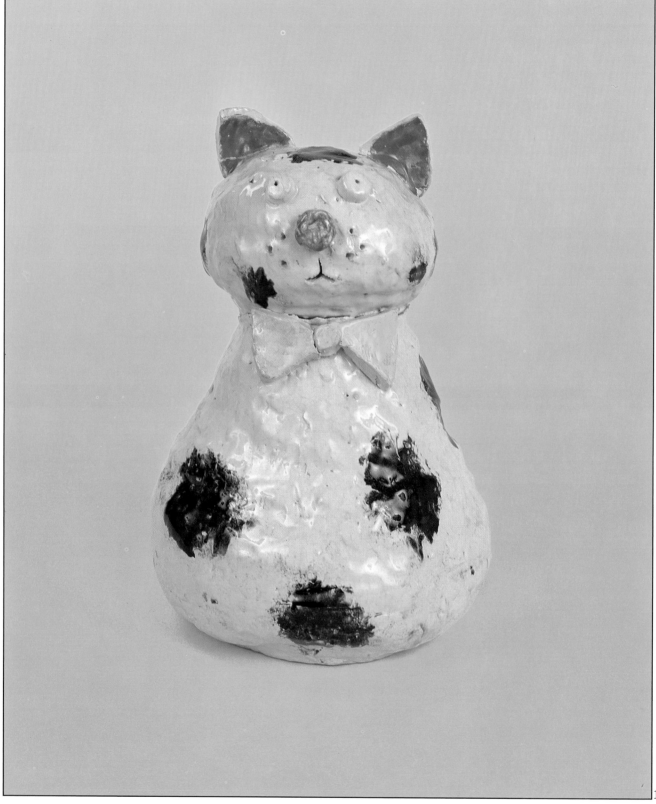

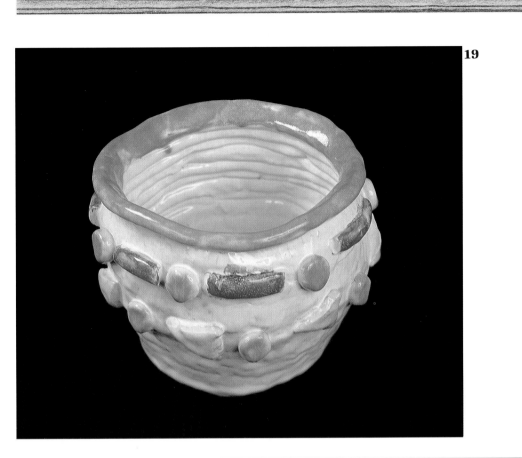

19

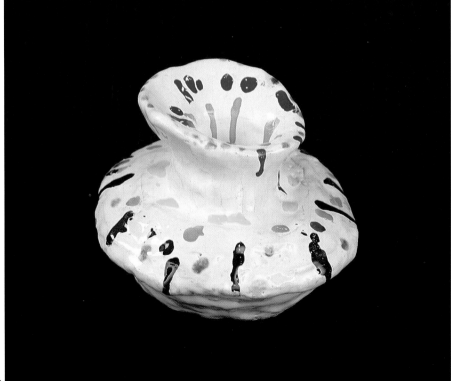

20

Collect some objects to push or roll into clay. Here are some ideas: leaves, shells, twigs, pieces of bark, a clothespin, a ballpoint pen, a screw and a fork.

You will need a board for working on, two boards for finished work, a piece of wedged clay (red or white) weighing about 4 pounds (2kg), your objects, an old dish towel, a rolling pin, two rolling guides, a needle and a ruler.

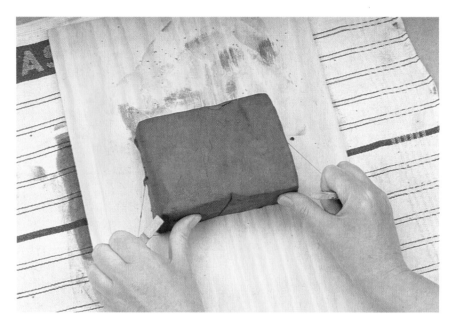

1 Wet the cloth and squeeze it out as hard as you can. Lay the damp cloth on the table with no creases. Halve the clay and bang it to make it flat.

2 Place the flat piece of clay on the cloth with a rolling guide on each side. Roll out the clay with the rolling pin. Short pushes are best. Start in the middle and work to the outside, rolling one half at a time. Then roll straight across. Keep the rolling pin clean and dry. If any air bubbles appear, prick them with the needle.

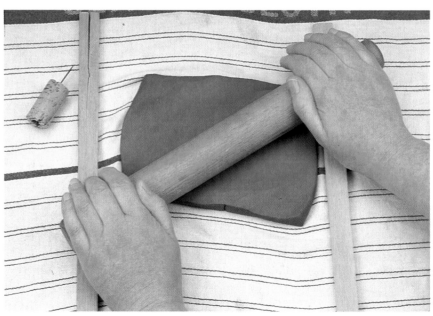

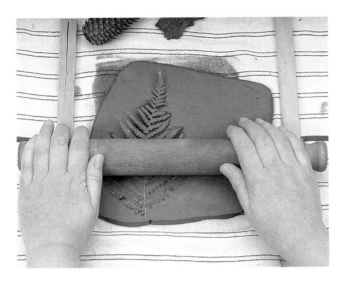

3 Take your objects and make exciting patterns in the clay. Flat objects, such as a leaf, can be rolled on to the clay with the rolling pin.

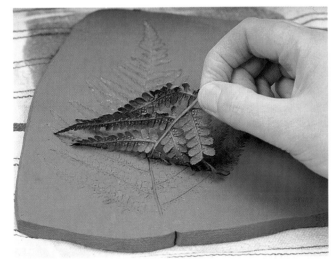

4 Gently remove the leaf and you will see that its shape has been impressed into the clay.

5 Try making patterns with more unusual objects such as shells, nuts, twigs or pine cones. If you don't like the pattern you have made, just smooth over the clay with your finger and start again. When you have settled on a pattern you like, lift the clay off the cloth and set aside.

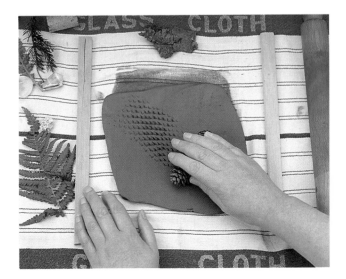

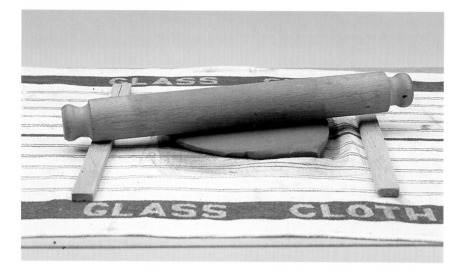

6 Now start again with the other piece of clay. This time the clay must be really flat. Check by bending down until you are at eye level with the clay. Push the rolling pin backward and forward over the clay. If you can see daylight between the rolling guides and rolling pin, the clay is not flat. Carry on until it is.

7 Repeat your chosen pattern on this new piece of clay.

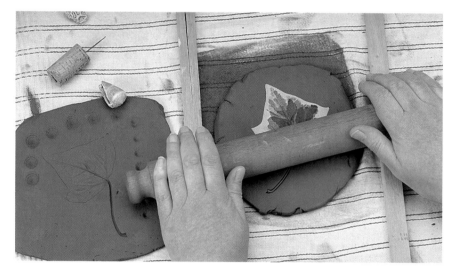

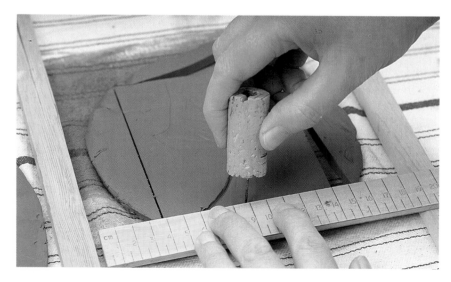

8 Using the ruler and needle, cut round the pattern. Remove any waste clay.

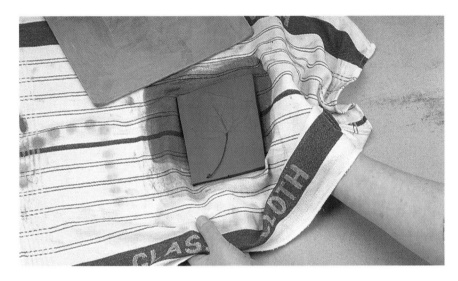

9 Transfer the tile on to your board to dry, but take care not to disturb the pattern. Slide your hand under the cloth and tile.

10 Place a board on top of the tile and turn everything over.

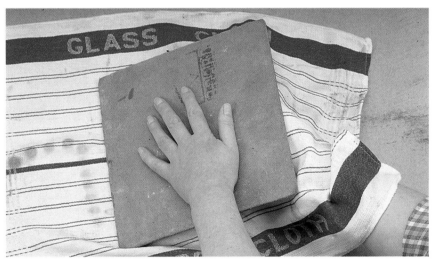

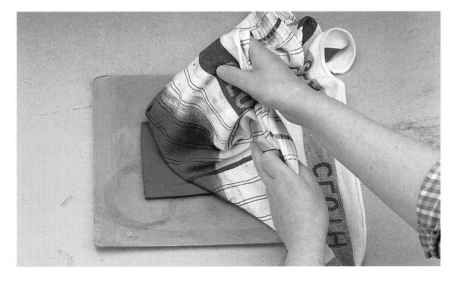

11 Gently pull the cloth away. The design is now face down.

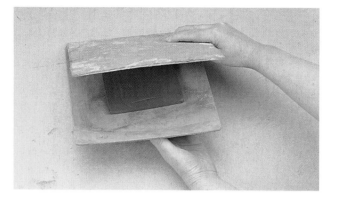

12 Place another board on top and turn over.

13 The design is now showing.

14 Set aside to dry.

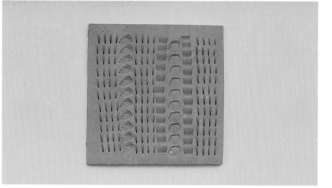

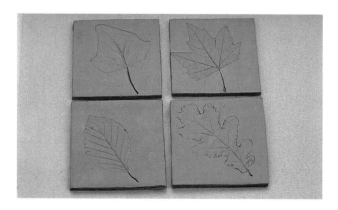

15 You can make a set of tiles by using a cardboard template of, say, 4 inches by 4 inches (10cm x 10cm). Roll out your clay (you could make alternate tiles of red and white clay). Impress a design. The four leaves shown here make an overall pattern. Put the template on the clay and cut round it with the needle. Repeat as many times as you wish – you could make enough to cover the bathroom wall!

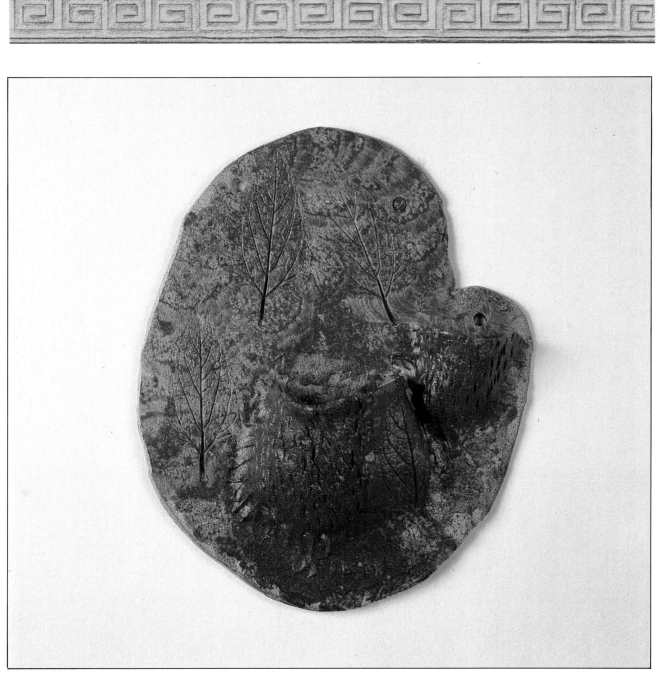

16 A variation of an
impressed tile for use
as a wall hanging.

When your tiles have had time to
dry a little, rub off any rough
edges with a nylon scourer,
taking care not to damage the
design. The tiles can then be
turned face down and allowed to
dry off completely.

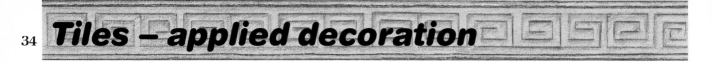

The patterns on these tiles are made by applying pieces of clay on to the damp surface of the tile and scraping away some background. This type of decoration is also known as "embossing" – carving and moulding on to a flat surface to give a three-dimensional effect.

You will need a board for working on, a board for finished work, a piece of wedged clay (red or white) weighing about 4 pounds (2kg), an old dish towel, a rolling pin, two rolling guides, a needle, a paintbrush, slurry (red for red clay, white for white), wooden tools and a fork.

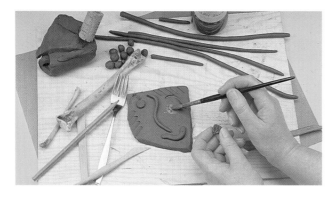

1 Follow the method shown in photos 1 and 2 on page 28, then cut out a rough shape from the piece of clay you have flattened. From the waste pieces, roll various sized pellets and coils. Join them to the flat surface by scratching and blobbing (see page 13), making a design.

2 Try cutting away some of the background with a wooden tool.

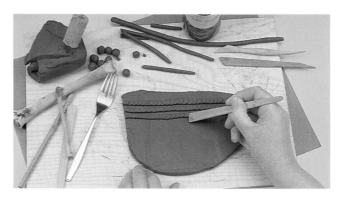

3 A fork can also be used to cut away some of the background. Make several designs, then choose the one you like best.

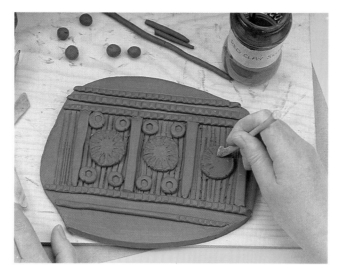

4 Roll out the other piece of clay, checking for flatness. Prepare your chosen design.

5 If you want to hang your tiles on a wall, you should make holes for screws at this stage while the clay is still soft. Use the handle of the paintbrush to make a hole on each side. (Make sure the holes are not too near the edge of your tile.) Set your tile aside to dry.

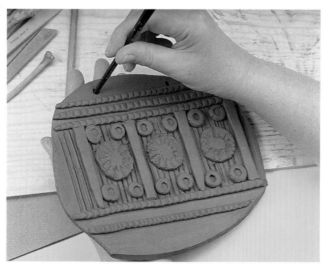

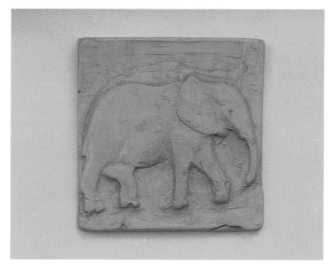

6 Try a simple flower or abstract pattern to start with. When you feel confident, try birds, fish, animals, buildings or landscapes.

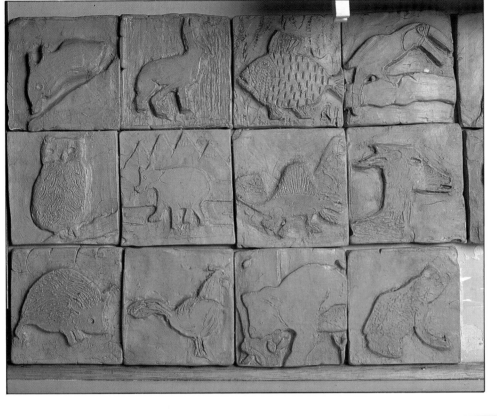

7 A collection of tiles can look very effective.

8 This fish plaque makes an unusual wall hanging.

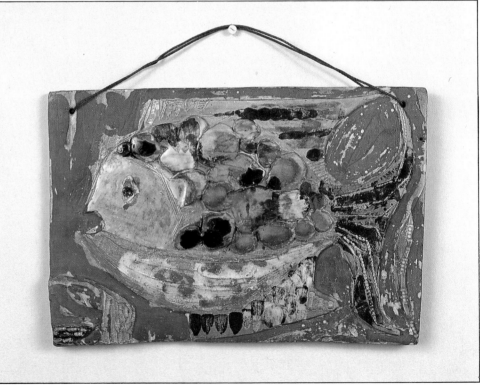

It is time to learn how to make a pot with angles. We are going to start by making a box, but once you have understood the method, you can be adventurous and the possibilities are endless.

You will need a board for working on, a board for finished work, wedged white clay (the amount you need will be dictated by the size of your box), thin card, a sharp pencil, a ruler, scissors, wire, a knife, an old dish towel, a rolling pin, two rolling guides, a needle, a paintbrush, slurry and a damp sponge.

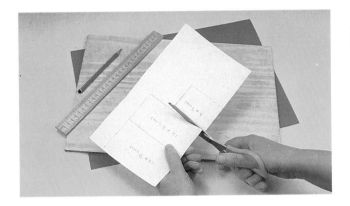

1 Cut templates for your box from the card. Here are some suggested measurements: *Base* 5 inches by 3 inches (12cm x 7 cm); *Sides* 5 inches by 2½ inches (12cm x 6cm); *Ends* 3 inches by 2½ inches (7cm x 6cm).

2 To prepare your clay, follow the method shown in photos 1 and 2 on page 28. Now place the templates on the piece of clay you have flattened and cut round the shapes with the needle. Try to cut at right angles with the clay.

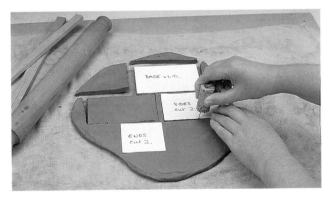

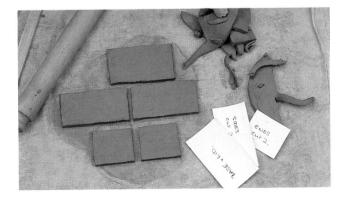

3 Take away the waste clay. Do not try to lift the cut shapes yet. They are too wet and you will distort them. Place your hand underneath the cloth and the shapes, and gently turn them over on to a board (see photos 9, 10 and 11 on page 31). Set aside to harden. If you want to impress or apply decoration on any of the sides, now is the the time.

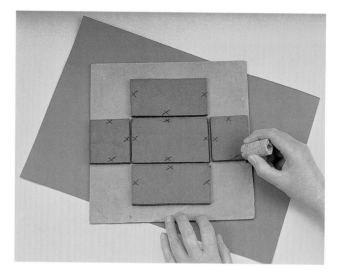

4 When the clay is hard enough to pick up without distorting the shape, it is ready to be assembled. Lay the five pieces on the table. Make "X" marks with the needle to show where the clay will be joined.

5 To cut an angle of 45° (2 x 45° = 90°, a right angle), put the base on the edge of the table and cut the clay towards you with the knife. Keep your thumb on the corner you are cutting. Cut all round the base but only on three sides of each of the walls. Scratch the edges with the needle, and blob slurry (see page 13).

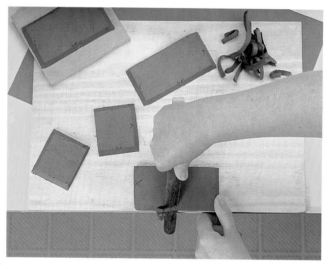

6 Place the base of the box on the board you are going to use for drying the work. Take one side and fix it to the base. Run your finger along the outside seam. The clay should stand up on its own. Quickly fix the remaining sides to the base and to each other.

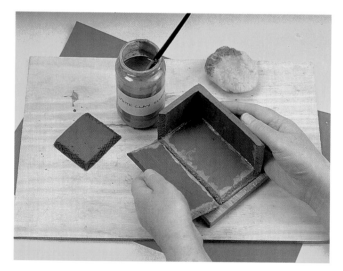

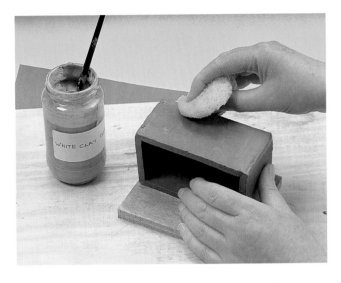

7 Smooth over the box edges with the sponge.

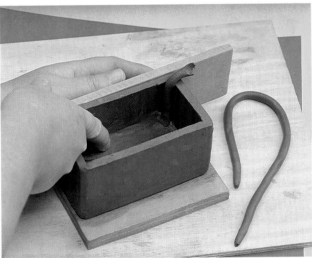

8 To make the seams really strong, roll thinnish coils and work them neatly into the seams on the inside. It is easy to open up the seams while doing this, so use one of the rolling guides as a support. It is worth spending time to get the inside really smooth.

9 Place your finished box on a board and set aside to dry.

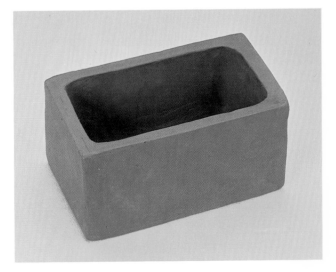

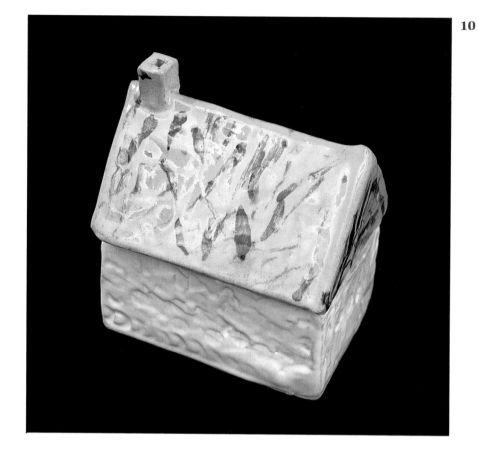

10

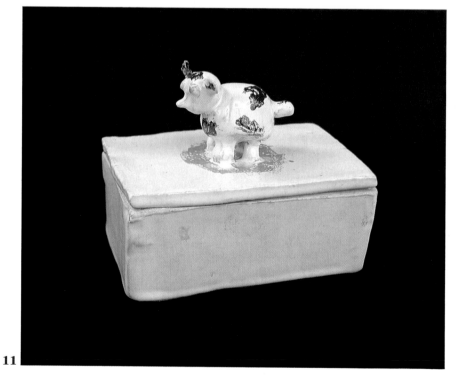

10 & 11 This cottage and butter dish began as boxes.

11

All clay pots have to be baked in a kiln. This is known as firing. Usually, pots are fired twice. The first is called the *bisque* firing. The second is called the *glaze* firing. Without firing or baking, clay will become soft again if it is put into water.

During the bisque firing, a clay pot is heated to a temperature of almost 1,000°C. The pot must be really dry before it is fired. If it is at all damp, it will crack. You may like to leave your pots drying for three weeks, just to be on the safe side.

After this first firing, the clay will look much lighter in color.

Glazing

Glaze is the coating which makes your clay pot waterproof. Glaze comes in different colors. To apply glaze to a pot you will need newspaper, glazes (choose the colors you want), sticks for stirring, paintbrushes (large and small), a damp sponge and a bowl of water.

Always read the labels on the jars of glaze – the color of the liquid is *not* how the final result will look. There is usually a color sample on the jar label. For your first attempt at glazing, I suggest you use only one color.

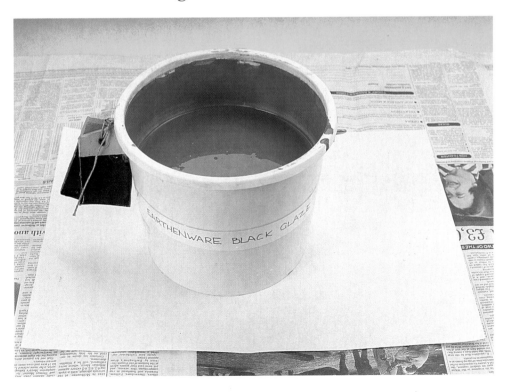

1 Spread the newspaper on the table. Pour the glaze into a plastic bucket. Stir the bucket of glaze well, until it is about the thickness of single cream. With very clean, dry hands, gently pick up your pot and blow off any dust. Pots have to be very clean and free of dust before glazing or the colors do not "take."

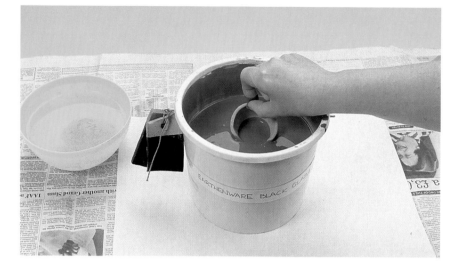

2 Dip the fingers and thumb you are going to hold your pot with, into the glaze to coat them. Pick up your pot and dip it right into the glaze.

3 Hold the pot in the glaze for a count of 1-5.

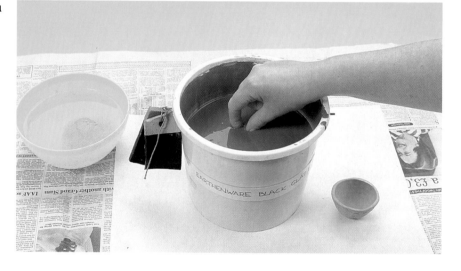

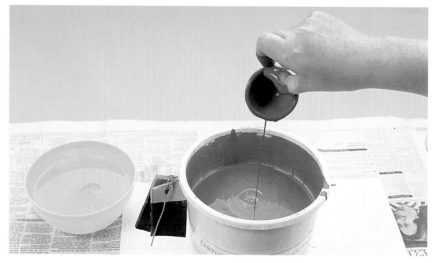

4 Lift the pot out of the glaze and tip out any liquid which remains inside.

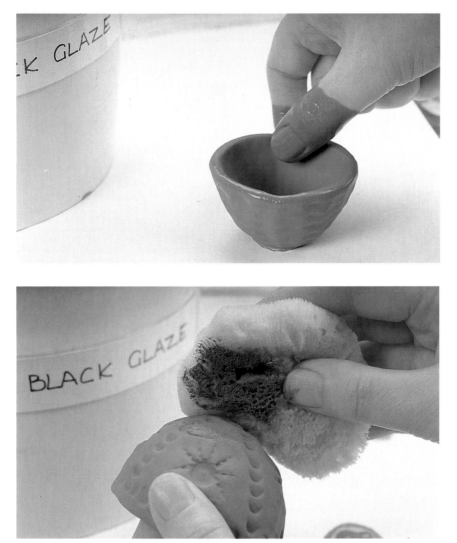

5 Place the pot on the newspaper. You will notice that the glaze dries almost immediately.

6 Glaze melts in the kiln, so if there is glaze on the bottom of your pot, it could be joined to the kiln shelf forever! With the sponge, wipe the bottom of your pot clean. The pot is now ready for its second and final firing. Glaze firing is done at a temperature of between 1,060°C and 1,080°C – even higher than bisque firing.

There are several methods of glazing – you have just used one called *dipping*. The next time you glaze, try blobbing on other colors with a brush after you have dipped your pot. Blobbing gives a much better result than painting. If you try to paint glaze on a pot you will find that the glaze picks off.

By the time you have tried out all the projects in this book, you will have covered the basic methods of working with clay. You should have begun to understand what clay will and will not do in your hands. You may still be having great difficulty in rolling coils for coil pots, but your slab pots may be almost perfect! You may have discovered a preference for painting, impressing or applying decoration to your work.

Only by designing and making more and more pots, as well as by experimenting with shape, texture and color, will you gain confidence and understanding. As with most things in life, the fun and enjoyment comes when the basic techniques have been mastered.

Here are some more ideas for you to try out. They are linked to the sections in the book. You should use wedged clay for all of them.

Pinch pots can be arranged in many ways. Try joining them on a center pole or side by side.

Coil pots are wonderfully versatile. Try using red *and* white clay alternately. Make a bowling pin shape, then add ears, eyes, nose, beak and turn the skittle into a penguin, owl or cat. Cut off the top to make a lid.

Slab pots can be very ornate. Make a set of tiles, or a simple jigsaw puzzle by cutting out shapes with a needle while the clay is still damp.

Roll the clay out on a piece of textured cloth such as fishnet. Then wrap the clay around a cardboard cylinder.

Roll leaves and other materials from nature on to the flat clay. Add a pocket and make two holes for screws. When finished and fired, hang on the wall.

Draw and cut out a fish or a bird in thin card. Place the card template on to some rolled-out clay, draw round lightly with a wooden tool, then apply *and* impress clay decoration.

I hope this book has started you off on the way to enjoying this craft. Have fun!

You will probably be able to locate suppliers of clay, glazes, wooden tools, and other pottery equipment through your local telephone book Yellow Pages, but here, too, are names of some of the mail-order suppliers you might write for a catalog.

AMERICAN ART CLAY COMPANY
4747 West Sixteenth Street
Indianapolis, IN 46222
ARMADILLO CLAY AND SUPPLY
3307 East Fourth Street
Austin, Texas 78702
M. GRUMBACHER, INC.
30 Engelhard Drive
Cranberry, NJ 08512
MINNESOTA CLAY COMPANY
8001 Grand Avenue South
Bloomington, MN 55420

ULTRA CERAMIC COLOR
1819 German Street
Erie, PA 16503
WESTWOOD CERAMIC SUPPLY
COMPANY
14400 Lomitas Avenue
City of Industry, CA 91746

Some helpful books

Gilbreath, Alice. *Slab, Coil, and Pinch: A Beginners Pottery Book.* New York: Morrow, 1977.
Powell, Harold S. *Beginners Book of Pottery.* White Plains, NY: Emerson, 1974.
Woody, Elsbeth S. *Handbuilding Ceramic Forms.* New York: Farrar, Straus & Giroux, 1978.
Gonen, Rivka. *Pottery in Ancient Times.* Minneapolis: Lerner, 1974.

A brief history of pottery

The history of pottery is fascinating, probably because it tells us so much about our ancestors.

Once a piece of clay has been fired or baked, it is permanent. It will not disintegrate when wet. It will break, leaving fragments called shards, but it is almost indestructible. Museums all over the world have pots, shards and clay tablets hundreds, even thousands, of years old with writing and drawings on them. These show us the sort of animals, birds and fish that lived at a particular time, as well as what the landscape was like. In

many countries in the world, whole pots have been found containing bones, human ashes, grain, and jewelry. From all this evidence, we can learn so much about people's ways of life, where they lived, the type of shelters they built, what they hunted and ate, what they wore, the range of weapons and tools they used, and what sort of burials they gave to members of their community. Pottery has helped archaeologists and historians find out more about early people than anything else.

Early tribes all over the world tended to build settlements near rivers and lakes. Since clay is found beside rivers and lakes, it is not difficult to imagine it being used to make cooking pots, storage jars, even decorative figures for special ceremonies.

Although we will never be certain, it is likely that the method of making clay hard was discovered by accident. A clay figure or reed basket lined with clay probably fell into the fire, and its owner found, to his or her surprise, that the result was a permanent object decorated on the outside with a reed pattern.

The earliest found pottery has been dated somewhere between 8,000 and 7,000 BC in Syria. It is interesting that from earliest times, humans have had the same basic requirements. Storage jars, cooking, drinking and eating vessels, and funerary urns for ashes have been found all over the Far East, East and Middle East. Those from Turkey, Syria, Egypt, Persia (now Iran), China and Japan seem to be the most ancient. You can see examples dating from between 5,000 and 4,000 BC in some of the world's museums.

In Egypt, clay tablets with writing on them have been found. These date from as early as 3,000 BC and give valuable information. We have learned, for example, that the wheel was invented in Egypt around this time.

Gradually travelers moved west, either by sea or over land. Pottery was introduced to Britain about 3,600 BC. The first objects to appear in this country were hand-built: funerary urns, cooking pots and pots for storing grain.

While people in Britain were

making these very simple shapes, the Eastern civilizations were getting more and more sophisticated. They were continually improving their method of firing, of building kilns, and of developing glazes. Pots were being commissioned by Emperors for ceremonial or ritual occasions. Pharaohs wanted to be buried with beautiful belongings. Tiles were made for the walls and floors of religious buildings and palaces. Again, examples of these can be found in most museums.

In the East, pottery became very popular and was used for trading. Painted decoration came with more knowledge of colors and firing. To keep up with the demand, factories were established in China as early as 1,200 AD, and their products used as export trade. Often, the travelers bringing their goods to trade settled and developed their skills.

Pottery became increasingly popular in the West, not just amongst the wealthy. During the 18th century the demand everywhere became so great that more and more factories sprang

up, and domestic pottery became much cheaper. We now all have mugs, jugs, bowls, plates and a teapot in our homes. A large amount is mass-produced in factories, but there are many potters who still make hand-made ware, ranging from unique ornaments to household items.

It is worth visiting national, local and traveling museums to see their collections of pottery objects. You will learn more about the history of pottery, but you will also get ideas for your own work. The methods of making pots shown in this book are the same as our ancestors used, although their tools would not have been machine-made, nor would they have had the glazes we use today. The first "glaze" was probably discovered by accident. Natural colors, called pigments, are found in the ground. Ash from a wood fire may have stuck on to a pot which was heating over the flames, and a shiny coating resulted.Since that time potters have been experimenting and developing with other ingredients to make the colors we have today.

Air 16, 19
Air bubbles 18, 19, 28
Angles 37, 38
Applied decoration 34-36, 37, 44

Bark 4, 28
Ballpoint 4, 28
Blobbing 43
Board 4, 6, 9, 12, 16, 20, 21, 24, 28, 31, 32, 34, 37, 38, 39
Britain 46
Bull's Head Method 18-19

Cardboard 4, 37, 44
China 46, 47
Clay
 Pellets 34
 Red clay 4, 5, 6, 12, 28, 32, 34, 44
 Sausages 20
 "Secondary" clays 5
 Waste clay 30, 34, 37
 Wedged clay 19, 20, 24, 28, 34, 37, 44
 White clay 4, 5, 18, 20, 24, 28, 32, 34, 37, 44

Clothes pin 4, 9, 28
Coil pots 20-27, 44
 With curved sides 23
 With straight sides 22-23
Coils 20, 21, 22, 23, 25, 34, 39, 44
 "Corkscrew" coil 20, 21
 "Dried up" coil 20, 21
 "Plank" coil 20, 21

Dipping 43
Drying clay pots 10, 41

Egypt 46
Embossing 34

Firing 5, 19, 41, 45, 47
 Bisque firing 41, 43
 Glaze firing 41, 43
Fork 4, 28, 34

Glaze 4, 5, 41, 42, 43, 45, 47
Glazing 41, 43

Impressed decoration 10, 16, 28-33, 37, 44

Japan 46
Jigsaw puzzle 44
Join line 14
Joined pinch pots 12-17

Kiln 4, 5, 25, 41, 43, 47
Knife 4, 6, 10, 37, 38

Leaves 4, 28, 29, 32, 44

Museums 45, 46, 47

Needle 4, 12, 13, 16, 28, 30, 32, 34, 37, 38, 44
Newspaper 4, 5, 41, 43
Nuts 4, 29

Paintbrush 4, 12, 13, 34, 35, 37, 41
Paper 4, 24, 25
Patterns 9, 10, 29, 30, 31, 32, 34, 35
Pencil 4, 24, 37
Persia (Iran) 46
Piggy bank 15, 16
Pigments 47
Pinch pots 6-11, 12, 16, 20, 44
"Pinch and turn" 6
Pine cones 4, 29
Plastic 12, 16

Plastic bag 4, 18, 19
Potters 5
Pottery 45, 46, 47

Rolling guides 4, 28, 30, 34, 37, 39
Rolling pin 4, 28, 29, 30, 34, 37
Ruler 4, 28, 30, 37

Scissors 4, 37
Scourer 4, 6, 10, 33
Scratching and blobbing 13, 15, 16, 34, 38
Screw 4, 9, 28, 35, 44
Seams 38, 39
Shards 45
Shells 4, 28, 29
Slab pots 37-40, 44
Slurry 12, 13, 14, 34, 37, 38
Sponge 4, 6, 7, 12, 20, 21, 24, 37, 39, 41, 43
Sticks 4, 41
String 9
Syria 46

Tea towel 4, 28, 34, 37
Template 32, 37, 44
Tiles 28-36, 44, 47
Turkey 46
Twigs 4, 28, 29

Vase 24-25

Wall hanging 33, 36
Water 4, 12, 41
Wedging 18-19
Wire 4, 6, 7, 18, 19, 37
Wooden tools 4, 6, 9, 12, 15, 34, 44, 45